A Distant Muse

Orientalist Works from the Dahesh Museum of Art

Dahesh Museum of Art

NEW YORK

2000

Dahesh Museum of Art

601 Fifth Avenue
New York, NY 10017
Telephone 212-759-0606
www.daheshmuseum.org

This book accompanies the exhibition
*A Distant Muse: Orientalist Works from the
Dahesh Museum of Art*
September 5 to December 30, 2000

Cover: Hermann-David-Salomon Corrodi, *Campfire by
the River: Kiosk of Trajan at Philae*, c. 1880 (cat. no. 30)

Back cover: After Jean-Léon Gérôme, *The Grand White
Eunuch*, 1881 (detail, cat. no. 17)

ISBN: 0-9654793-5-8
Library of Congress catalogue no. 00-108766

Photography: Robert Mates
Design: Lawrence Sunden, Inc.
Printing: The Studley Press

A Distant Muse

Orientalist Works from the Dahesh Museum of Art

Table of Contents

Foreword

ORIENTALIST ART engages both the emotions and the intellect as much as, if not more than, any other aspect of 19th-century art. From the early decades of that century well into the 20th, it was created with a variety of motives and collected passionately in the Western world. While aspects of Orientalist representation could be considered part of traditional artistic genres—history painting, scenes of everyday life, landscape—its unique sensibility allows its diverse parts to be considered as a single, if very complicated, phenomenon. In the 21st century, issues around Orientalism are now debated urgently, and Middle-Eastern collectors—descendants of its original subjects—compete with European and American collectors for choice works.

The Dahesh Museum of Art, the only museum in the United States dedicated to European academic art of the 19th and early 20th centuries, has from its inception recognized the importance of Orientalism in the cultural history of the West and now has an extensive collection of Orientalist art in all media, including salon history painting, images of everyday life, colorful landscapes, reference texts, and popular illustrations. *A Distant Muse* is the third Orientalist exhibition organized by the Dahesh Museum of Art and its second publication devoted to it. Lisa Small, the Museum's Research Associate, has written an outstanding essay for this catalogue that succinctly summarizes this very complex movement and its effect on our perceptions of the Middle East.

Following its showing in New York, *A Distant Muse* will travel in modified form to Palm Beach's elegant Henry Morrison Flagler Museum and other institutions in the United States and abroad.

The exhibition was organized by Dahesh Museum of Art Curator Stephen Edidin with the assistance of Lisa Small. Assistant Registrar Richard Feaster coordinated the tour of the exhibition.

I want to extend special thanks to the Trustees of the Museum, who have supported the development of the collection and the investigation of the historical and intellectual issues that are so much a part of Orientalism.

J. David Farmer
Director

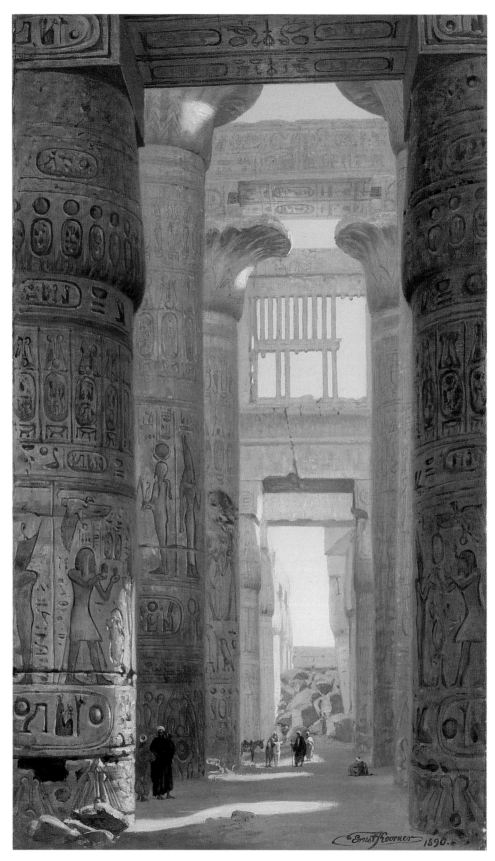

Frontispiece: Ernst Karl Eugen Koerner (German, 1846–1927), *The Temple of Karnak, The Great Hypostyle Hall*, 1890, oil on canvas, 31¼ x 18¼ inches. Dahesh Museum of Art, 1995.114.

Western Eyes, Eastern Visions

GETTING ORIENTED

To orient oneself—both physically and mentally—is to determine one's position in relation to the surrounding area: to establish a fixed point from which everything else may be surveyed and understood. The geographical connotation of this familiar use of the word orient echoes its original definition. Orient is derived from the Latin word for East and has long been the name Western Europe (the Occident) used for the lands of the Ottoman Empire, which at its peak included Turkey, North Africa, Egypt, Syria, Greece, parts of Eastern Europe and the regions known as The Holy Land. India, China and Japan were also considered the Orient, indicating that the term did not refer to one place, nor even to a single direction—North Africa is, in fact, south of Europe. The Orient was, as much as anything else, a concept invented by the West to serve as an integral part of its own self-definition. In both a literal and figurative sense, the West oriented itself by facing East, stabilizing and normalizing its own characteristics by contrasting them to those perceived in the Orient. A clear example of this Occidental worldview is expressed in the preface to one of the most influential early 18th-century collections of images of the Orient, Jean-Baptiste Vanmour's *100 Prints Representing Different Nations of the Levant* (1712–13):

> The reader imagines himself inspecting the other inhabitants of the Earth, and exercising over them a kind of sovereignty, he examines them with attention, approves or condemns their choice of customs, amuses himself and often laughs at the oddness of some, sometimes admires the beauty and majesty of others, always preferring the customs of the country where he was born.

The vast body of art and scholarship resulting from the Western drive to examine cultures and lands quite different from their own is known as Orientalism. The words and images that comprise this phenomenon are often, but not exclusively, proprietary and demeaning in nature, yet they remain among the most compelling creations in Western cultural history.

This exhibition focuses on the visual arts of the 19th century, the period in which Orientalism flourished in the wake of Napoléon Bonaparte's ill-fated military campaign in Egypt (1798–1801). By that time the term Orient pertained primarily to the politically unwieldy and ethnically diverse Ottoman Empire. (In this essay the terms East and Orient will be used interchangably to refer to this area.) Following the example of Eugène Delacroix, who traveled to Morocco in 1832, more and more artists began to venture East. By 1859 the romantic novelist and art critic Théophile Gautier claimed the Orient as the destination of choice for artists, using two of the more common stereotypes to describe its appeal:

> The voyage to Algiers is becoming as indispensable for painters as the pilgrimage to Italy; they go there to learn of the sun, to study light, to seek out unseen types, and manners and postures that are primitive and biblical.

The people, customs, history and topography of these regions were rendered in oils, inks and bronze, exhibited to much acclaim and collected by the wealthiest art patrons of the day. Orientalism's motifs inspired the imaginations of disparate artists, including academician Jean-Léon Gérôme, topographer David Roberts, historical fabulist Edwin Long, Impressionist Auguste Renoir and Symbolist Gustave Moreau—even Henri Matisse invoked the Orient in a number of his paintings. The poles of canonical 19th-century art, Romanticist Eugène Delacroix and Neoclassicist J.A.D. Ingres, produced some of their most celebrated images under the sign of Orientalism, offering further evidence that the history of 19th-century art is less one of strict demarcation and opposition than of fluidity and mutual attraction.

Nevertheless, Orientalism has come to be most closely associated with academic art. The fundamentally documentary aspect of Orientalism, its ethnological interest in accuracy and capturing the specificities of a place, was well served by the meticulous detail, realism and narrative focus that characterize the academic style. (The *avant-garde* at this time

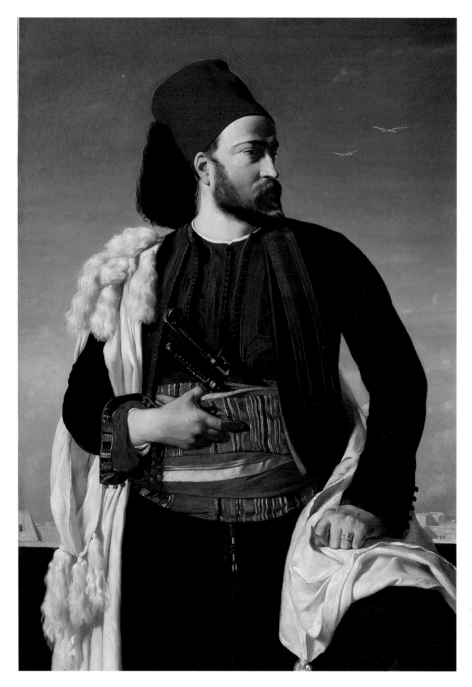

1. François-Léon Benouville (French, 1821–1859), *Portrait of Leconte de Floris in an Egyptian Army Uniform*, 1840, oil on canvas, 52¼ x 35½ inches. Dahesh Museum of Art, 1997.34.

turned to Japan, the other Orient, not for the country's varied subject matter, but for the formal innovations of its art.) Nineteenth-century Orientalism was also in the main a French phenomenon, due in no small part to the enormous consequences of Napoléon's expedition, although, as this exhibition demonstrates, artists throughout Western Europe and America were attracted to the subject.

The Orient loomed large in the Occidental collective consciousness. It was at once an actual place that could be visited and depicted with more or less verisimilitude, and an imaginary construct whose meaning was determined by what a particular artist or viewer wanted, or needed, to see. These images of caravans, mosques, markets, harems, warriors and dancers may thus be interpreted on two levels: as windows onto fascinating Eastern cultures, and as mirrors reflecting the fears, desires, condemnation and admiration of the West.

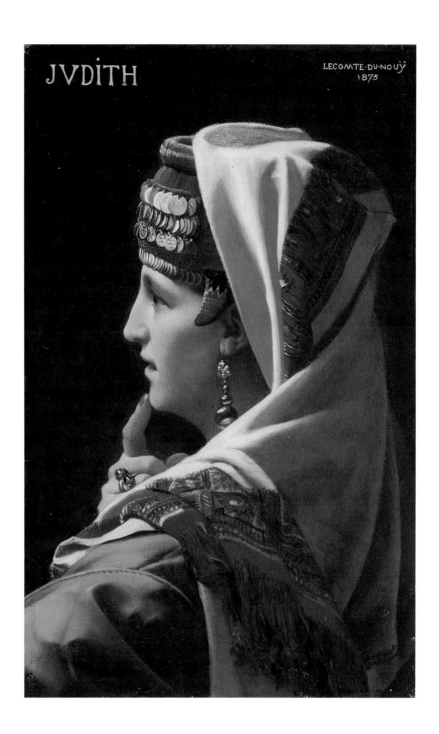

JVDITH

LECOMTE·DV·NOUŸ
1875

2. Jean Jules Antoine Lecomte du Nouÿ (French, 1842–1923), *Judith*, 1875, oil on panel, 12⅝ x 18⅛ inches. Dahesh Museum of Art, 1999.3.

MAGI AND MASQUERADE

Although the popularity of Orientalism reached its apogee in the 19th century, Oriental motifs appeared in Western religious art as early as the 15th century, often in the guise of robed and turbaned Magi (with camels) adoring the Christ child. In 1479–80 Venetian artist Gentile Bellini traveled to Constantinople as the guest of Sultan Mehmet II, whose portrait he painted. In the 17th century Rembrandt gave his Old Testament kings turbans and vivid robes to signal their Eastern origin. Aside from dark complexions and vaguely exotic costumes, however, artists in this earlier period did not manifest any further "Oriental" characteristics in their figures. By the 19th century, many artists sought to make their biblical subjects more true to Middle-Eastern physiognomies, while others still relied primarily on props and costumes. Jean Jules Antoine Lecomte du Nouÿ, a favorite pupil of Gérôme, painted a beautiful image of the Old Testament heroine Judith wearing an ornate headdress decorated with coins that looks like a *shatweh*, a

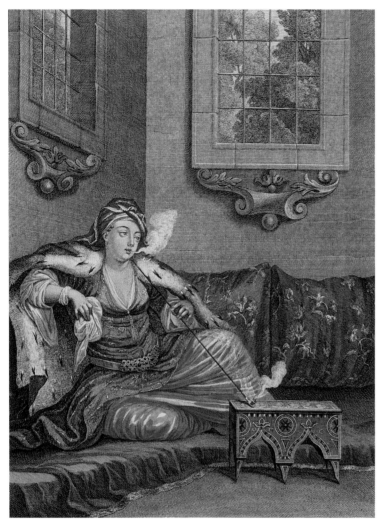

3. After Jean-Baptiste Vanmour (Flemish, 1671–1737), *Turkish Woman Smoking on the Sofa*, 1712–13, engraving, 12⅟₁₆ x 9⁵⁄₁₆ inches. Dahesh Museum of Art, 1999.11.

Four Books of Oriental Navigations and Peregrinations (1568), George de la Chappelle's *Collection of Various Portraits of the Principle Women of the Porte* (1648), and Paul Rycaut's *Collection of Various Turkish Figures* (1670) presented the many "types" of the Ottoman Empire, and ranged from the entirely fanciful to the surprisingly accurate.

In the 18th century, the official visits to Paris by Persian ambassador Riza Bey (1714) and the Turkish embassies of Mehmet Effendi (1721) and Said Effendi (1742) were captured in numerous portraits and reception pieces, raising the Orient's profile in Occidental culture to new heights. The splendid Turkish costumes seen at these lavish occasions generated the most interest, and it soon became the rage to dress *à la turque*. In 1748, students and faculty at the French Academy in Rome held a carnival party where everyone dressed up as members of the Turkish court. This kind of theatrical Orientalism flourished during the Rococo period, when painters like Carle Van Loo depicted the French King, Queen and other aristocrats masquerading as pashas and sultanas. It is interesting to note that in the 19th century, when Oriental and Occidental culture were even more deeply entwined, this tradition of masquerade sometimes reached a new level of complexity. The French official in François-Léon Benouville's *Portrait of Leconte de Floris in an Egyptian Army Uniform* (1840), for example, wears the uniform of the new Europeanized army created by former French officers hired by the Egyptian government: the West masquerading as the East masquerading as the West (cat. no. 1).

Having one's portrait painted in Oriental regalia was a must for many in the upper classes, especially those—like ambassadors and their wives—whose professions took them to that part of the world. The demand for such works was so great in the 18th century, particularly at the opulent Ottoman court (the Sublime Porte), that a number of European artists established themselves there permanently. Among the most successful was Flemish painter Jean-Bap-

marriage hat worn by women in Bethlehem (cat. no. 2). The artist probably saw one of the many photographs of this costume in circulation at the time and adopted it to authenticate his Judith as a Middle-Eastern woman. But Judith herself, as is sometimes the case with Lecomte du Nouÿ's Oriental women, has the marmoreal skin and aquiline profile of a classical sculpture.

Few artists made their way to the Orient in the 16th and 17th centuries as military conflicts between the Ottoman Empire and Western Europe became increasingly aggravated: Vienna, for example, narrowly missed being captured by the Ottoman army in 1683. The region and its people were frequently depicted, however, in the plethora of travel books produced by the writers and illustrators who accompanied Western ambassadors to Constantinople. These accounts, like Nicolas de Nicolay's *The First*

tiste Vanmour, whose patrons included English ambassador Sir Edward Wortley Montagu and his wife, the author Lady Mary Wortley Montagu.

Vanmour was an indefatigable chronicler of the Ottoman court and its spectacles—official processions, audiences with the Sultan, religious ceremonies—and in 1725 he was named *peintre ordinaire* (court painter) to Sultan Ahmed III. But it was the numerous full-length portraits of the different members of Ottoman society that he executed earlier in the century that earned Vanmour his greatest fame. Charles de Ferriol, French ambassador to the Court of Sultan Mustapha II from 1699 to 1710, commissioned the engraving of 100 of these figure studies by Vanmour, which were then bound together in a book called *100 Prints Representing Different Nations of the Levant*, first published in 1712–13. In all the images the emphasis is on costume—fur-trimmed robes, jeweled sashes and elaborate turbans—and indeed it was these prints that brought the vogue for Turkish fashion to its widest audience (cat. no. 3). These images also served as a template for other artists in search of Eastern authenticity. Figures that were clearly inspired by Vanmour's prototypes, or even lifted in their entirety, can be seen in works by François Boucher, William Hogarth, Ingres and Gérôme, to name just a few.

THE TIME I SPENT IN EGYPT WAS THE MOST BEAUTIFUL OF MY LIFE.
—Napoléon Bonaparte

The golden age of Orientalism truly began on July 1, 1798, the day General Napoléon Bonaparte's flagship, the *Orient*, appeared off the coast of Egypt. The expedition, which was shrouded in secrecy, had a variety of military and political goals. France wished to demolish British hegemony in the Mediterranean, annex Egypt as a colony, and use it strategically to gain overland access to India and wrest it from British control. Despite an auspicious beginning, marked by decisive victory over the Mameluk cavalry at the Battle of the Pyramids and a highly organized occupational regime established in Cairo, Napoléon's fleet suffered a humiliating defeat by Admiral Nelson at Aboukir Bay in August of 1798. Pushing on toward Syria, Napoléon routed the Turkish army at Nazareth and again at Aboukir in 1799, but plague in Jaffa, resistance in Acre, a demoralized army and no prospect of reinforcements effectively doomed France's dreams of an Egyptian colony.

History painters in the early 19th century, however, preserved Napoléon's exploits in this region, spinning both his victories and his defeats into hagiography. In the grand set pieces *Battle of Nazareth* (1801, Musée des Beaux-Arts, Nantes) and

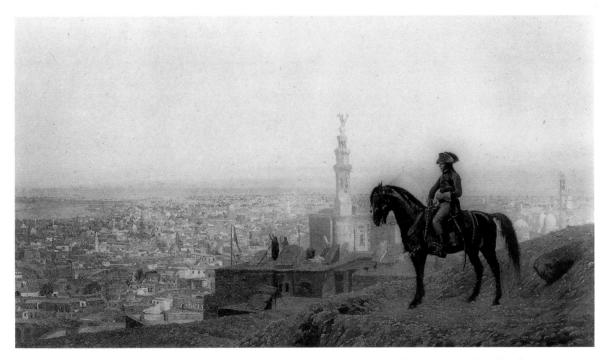

4. After Jean-Léon Gérôme (French, 1824–1904), *General Bonaparte at Cairo*, 1881, photogravure, 11½ x 17⅛ inches. Dahesh Museum of Art, 1997.55E

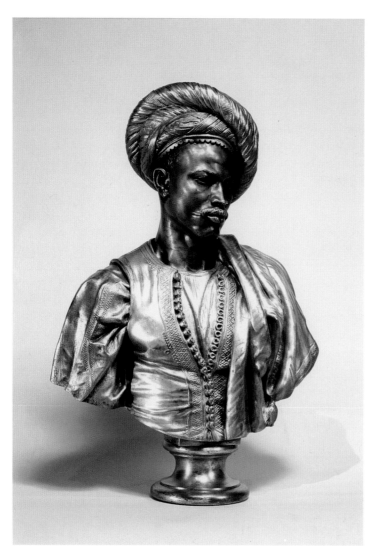

5. Charles-Henri-Joseph Cordier (French, 1827–1905), *A Sudanese in Algerian Costume*, c. 1857, silvered bronze, 16¾ x 6¼ x 12¼ inches. Dahesh Museum of Art, 1997.38.

Battle of Aboukir (1806, Musée National du Château, Versailles), Antoine-Jean Gros opposed the bravery and honor of French troops to the barbarism and cruelty of the Turks. This kind of bloodlust was a common Orientalist stereotype that would be deployed continuously in the 19th century, from the lushly painted violence in Delacroix's *Death of Sardanapalus* (1827, Musée du Louvre, Paris) to the photographically rendered decapitated heads in Gérôme's *Door of the El-Hassanein Mosque in Cairo* (1866, Private Collection).

Even Napoléon's disastrous experience in Jaffa, where he ordered French soldiers suffering from the plague to be poisoned rather than rescued, was made heroic. In *General Bonaparte Visiting the Pesthouse at Jaffa* (1804, Musée du Louvre, Paris), Gros depicted Napoléon touching the infected sore of one victim—a

healing, Christ-like gesture set pointedly against a background of dilapidated Islamic architecture. Genre painters too, like Gérôme, glorified Napoléon in Egypt. *General Napoléon at Cairo* portrays him astride his steed, surveying from a position of dominance the land he seeks to conquer (cat. no. 4).

Although he was thwarted militarily, the Egyptian campaign still remains one of Napoléon's greatest achievements. For along with soldiers and arms, Napoléon brought scholars and artists, whose brief it was to systematically document Egypt's flora, fauna, landscape and monuments—in short, everything they could see. They were organized in Cairo by Napoléon into the Institute of Egypt, a counterpart to the premiere academic body in Paris. France's best scientists, draftsmen, linguists, naturalists and antiquarians were thus mobilized like a secondary army who, unlike the actual military, succeeded in "capturing" Egypt for France and, ultimately, the rest of the West. By orchestrating this massive cultural endeavor—which was of great personal interest and importance to him—Napoléon ensured his legacy as the signal force behind Egyptology. Archaeologist Baron Dominique Vivant Denon, a major figure in the Institute of Egypt, dedicated his key work of early Egyptology, *Travels in Upper and Lower Egypt* (1802), to the then Emperor Napoléon:

> To associate the glory of your name with the splendor of the monuments of Egypt is to combine the grandeur of our century with the mythical eras of history; to rekindle the ashes of Sesostris and Mendes, who, like you, were conquerors, like you, were benefactors.

TYPECASTING

The Institute of Egypt's major publication, a multi-volume encyclopedic tome called *The Description of Egypt*, published between 1809 and 1828, was an astonishing achievement that prompted archaeolo-

6. Peder Mork Mønsted (Danish, 1859–1941), *Portrait of a Nubian*, undated, oil on panel, 9¼ x 7½ inches.
Dahesh Museum of Art, 1995.23.

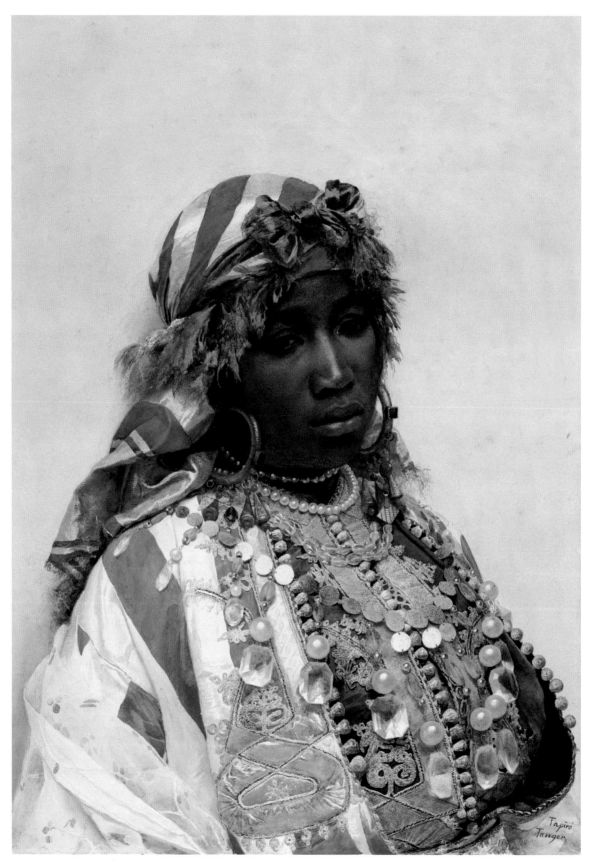

7. José Tapiró Baró (Spanish, 1830–1913), *A Tangerian Beauty*, c. 1876, watercolor, 26 x 18½ inches.
Dahesh Museum of Art, 1995.117.

gists, scholars and artists from all over Europe to explore Egypt for themselves. *The Description of Egypt* sought to explain, dissect and diagram its subject completely and rationally. At the heart of this method was categorization, a drive to organize the material at hand, whether it was the various species of fish found in the Nile, or the people who lived on its banks. This kind of taxonomic approach, in which people and their roles in society are identified and classified according to costume and accoutrements, existed long before publication of *The Description of Egypt*. The prints made after Jean-Baptiste Vanmour a century earlier, for example (cat. no. 3), which illustrated the Sultan, members of his household and court, ordinary Turks and the various ethnic groups that inhabited the Ottoman Empire, were still considered by many in the 19th century to be a field guide to the Orient.

As the range of early printed matter mentioned previously suggests, depicting types had long been a key element of Orientalism. In the 19th century these representations became even more prevalent as artists became ethnographers, seeking in their work to carefully distinguish among the vast array of physiognomies and garb found in the Ottoman Empire. Gautier praised this talent in Gérôme: "No artist seizes as well as he the typical accent of races, the local character of costumes, the exotic variety of accessories . . . He exhibits penetrating accuracy."

This desire to place art in the service of science is also exemplified in the work of sculptor Charles-Henri-Joseph Cordier (cat. no. 5). He was related by marriage to the director of the Musée nationale d'histoire in Paris and served from 1851 to 1866 as its official ethnographic sculptor, creating a series of busts for the museum's new ethnographic gallery. In 1856 he was awarded a commission from the French government to visit Algeria for the purpose of studying and reproducing in sculpture "the different indigenous types of the human race." Cordier adopted the academic tradition of the ideal, explaining that his goal in each of these works, such as *A Sudanese in Algerian Costume* (ca. 1857), was to produce "a general type combining all the beauties specific to the race under study." In a fascinating intersection of Orientalism, art, colonialism and commerce, fifty of Cordier's ethnographic busts, made from onyx mined in ancient Algerian quarries reopened by French colonists, were displayed at the Exhibition of the Products of Algeria held in Paris in 1860.

Many 19th-century guidebooks still described Arabs in harsh terms. The 1878 edition of Baedeker's handbook on Egypt stated that Arabs "occupy a much lower grade in the scale of civilization than most of the Western nations." But artists clearly found beauty and nobility in the people they depicted. Cordier himself claimed that his work "widen[ed] the circle of beauty by showing that it existed everywhere." Peder Mork Mønsted's pensive *Portrait of a Nubian* (cat. no. 6) conveys a sense of strength and dignity, and the face of the woman in José Tapiró Baró's *A Tangerian Beauty* is splendid in repose amid the glitter of her many jewels and scarves (cat. no. 7).

8. Lehnert & Landrock Studio (Rudolf Lehnert, Austrian, 1878–1948; Ernest Landrock, Austrian, 1878–1966), *A Young Girl of Extreme Southern Tunisia*, early 20th century, hand-colored photogravure, 11¼ x 15¼ inches. Dahesh Museum of Art, DM1478.

Soon after its invention in 1839, photography played a major role in shaping the West's perceptions of the East. Oriental subjects became so popular that many Western photographic companies established studios in major cites like Cairo, Beirut and Tunis. Some of them, like Lehnert & Landrock of Austria, are still in operation today. Among the most prevalent subjects were ethnographic studies of women in decorative, culturally distinct costumes. Such images were favored by tourists seeking souvenirs and by painters looking for *aide-mémoires*. Advertised as

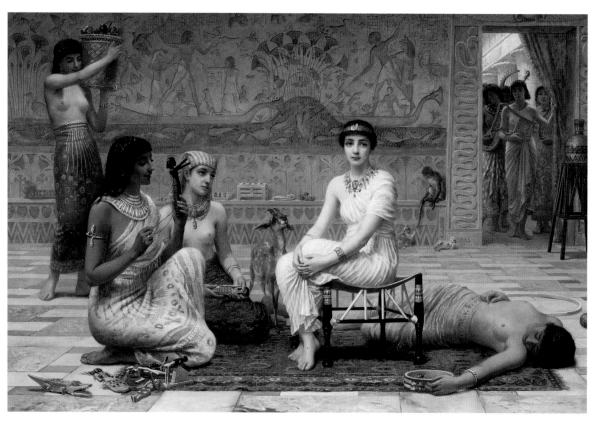

9. Edwin Longsden Long (British, 1829–1891), *Love's Labour Lost*, 1885, oil on canvas, 50 x 75¼ inches. Dahesh Museum of Art, 1995.10.

10. From *Manners and Customs of the Ancient Egyptians* by John Gardner Wilkinson, First Edition (London: John Murray, 1837). Dahesh Museum of Art, L1998.43.

"types" or "Arab Oriental Costume Scenes," these photographs were frequently choreographed using posed, professional models. The power of photography to signal "reality" is so strong, however, that many such pictures were used to illustrate documentary travel or ethnographic texts. The Lehnert & Landrock Studio's stylized picture *A Young Girl of Extreme Southern Tunisia* (cat. no. 8), for example, appeared in the January 1914 issue of *National Geographic* magazine, accompanying a long article entitled "Here and There in North Africa."

IMAGE AND TEXT

Genre painting—that is, scenes of everyday life and activities rendered in an apparently realistic manner—dominated Orientalist art by the mid-19th century. By that time many artists had seen the Orient for themselves and could rely upon their own notes and observations. Others never made the trip yet still made careers out of Orientalism. All artists needed accurate, current information about the customs, clothing and surroundings of their subjects to make their genre scenes appear authentic. Whether they required historical, architectural or ethnographic details, they found many descriptive books at their disposal. Like *The Description of Egypt*, such books sought to codify particular aspects of the Orient and, in turn, were secondary source material for both the well-traveled and stay-at-home Orientalist.

John Gardner Wilkinson's *Manners and Customs of the Ancient Egyptians*, first published in 1837, formed the basis for the English-speaking world's popular image of ancient Egypt for much of the 19th century. One of the founders of British Egyptology, Wilkinson spent twelve years working on excavation sites and his book reproduced numerous wall reliefs, texts, furnishings and other unearthed artifacts. Wilkinson's book provided key details for the many artists, like Edwin Long, who specialized in paintings set in ancient Egypt (cat. no. 10). Wilkinson illustrates most of the objects seen in Long's *Love's Labour Lost* (cat. no. 9), providing the image of scantily clad women with an erudite, archaeological gloss. By the time Long's painting went on view at the Royal Academy in 1885, these artifacts could also easily be seen in the British Museum. Other practitioners of this genre, like American Frederick Arthur

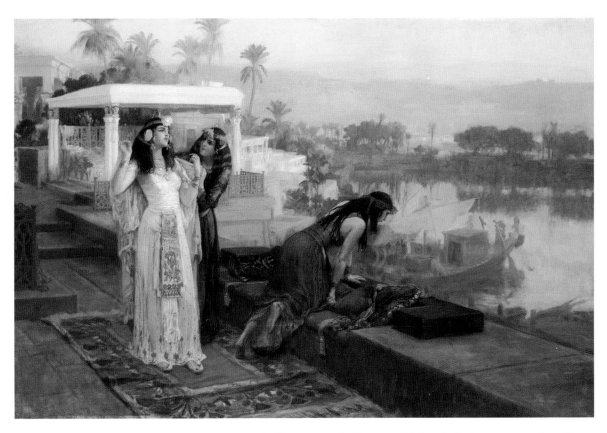

11. Frederick Arthur Bridgman (American, 1847–1928), *Cleopatra on the Terraces of Philae*, 1896, oil on canvas, 29⅞ x 46⅛ inches. Dahesh Museum of Art, 1999.5.

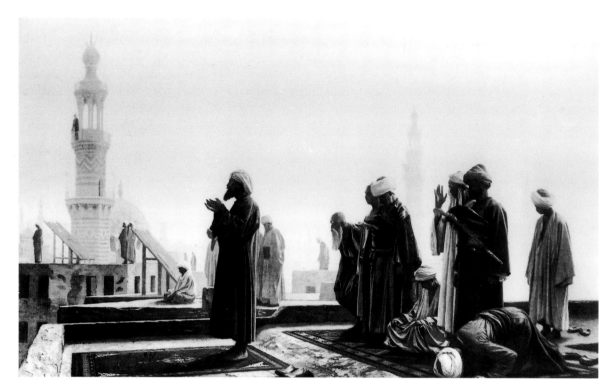

12. After Jean-Léon Gérôme (French, 1824–1904), *Prayer on the Housetop*, 1881, photogravure, 11½ x 17⅞ inches. Dahesh Museum of Art, 1997.55A.

Bridgman, were less reliant upon a profusion of archaeological details in their compositions. His theatrical *Cleopatra on the Terraces at Philae* (cat. no. 11), suffused in a pink sunset glow, is less concerned with Egyptology than with anecdotal charm. An archaeological connection to ancient Egypt might have been made by viewers who saw the painting at the National Academy of Design in New York in 1897, just sixteen years after the ancient obelisk Cleopatra's Needle, a gift from the Egyptian government, was installed in Central Park.

The most important sourcebook for contemporary Egypt was Edward William Lane's famous and exhaustively detailed *An Account of the Manners and Customs of the Modern Egyptians*, first published in 1836. In his original preface Lane stressed the work's "correctness" and went on to assert, "that I am not conscious of having endeavored to render interesting any matter that I have related by the slightest sacrifice of truth." The wealth of information in Lane's book on clothing, jewelry, musical instruments and the habits of everyday life was unquestionably valuable to artists, as were his illustrations, made, according to Lane, "merely to explain the text." His renderings of the Islamic postures of prayer (cat. no. 13), for example, certainly informed some of Gérôme's prayer paintings (cat.

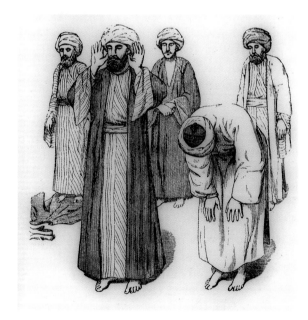

13. From *An Account of the Manners and Customs of the Modern Egyptians* by Edward William Lane, Fifth Edition (London: John Murray, 1860).

no. 12). Gérôme so successfully absorbed the "truth" and "correctness" of Lane's work that the 1895 edition of *Manners and Customs* included an unattributed engraving after Gérôme's *The Call to Prayer*, itself becoming now "merely" an explanation of the text. The pitfall here is that "truth" and

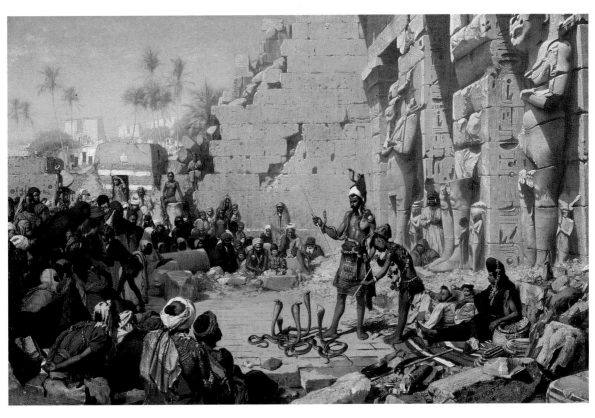

14. Karl Wilhelm Gentz (German, 1822–1890), *The Snake Charmer*, 1872, oil on canvas, 23½ x 36½ inches. Dahesh Museum of Art, 1995.54.

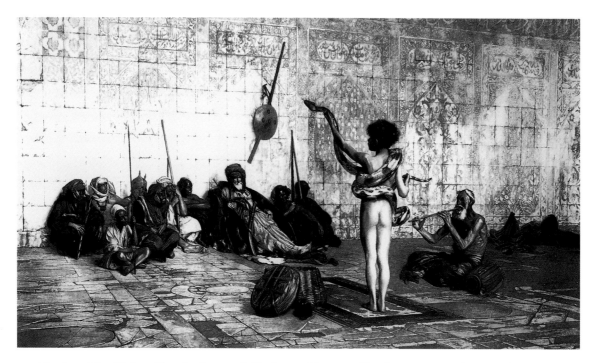

15. After Jean-Léon Gérôme (French, 1824–1904), *The Serpent Charmer*, 1881, photogravure, 11½ x 17⅛ inches. Dahesh Museum of Art, 1997.60A.

"correctness" often meant something quite different to an artist like Gérôme, schooled in the academic tradition of the ideal. Although the Cairo cityscape in the background of *The Call to Prayer* is correct in its details, Gérôme manipulated building locations, directions and distances to create a more perfect composition. This was accepted practice in both the literary and artistic circles in which Gérôme moved. In the dedication to his Orientalist novel *Le Fellah*, critic Edmond About wrote to Gérôme:

> Your example, my dear Gérôme, has at once fascinated and reassured me. No law forbids an author to work *en peintre*; that is to say, to assemble in a work of imagination a multitude of details taken from nature and scrupulously true, though selected. Your masterpieces, great and small, do not affect to tell everything; but they do not present a type, a tree, the fold of a garment, which you have not seen.

Another example of a carefully composed Orientalist image used to illustrate an ostensibly documentary text may be seen in Georg Ebers book called *Egypt: Descriptive, Historical, and Picturesque*, published in English in 1878. Ebers reproduces a painting called *The Snake Charmer* by Karl Wilhelm Gentz, a successful German Orientalist who had visited Egypt, Palestine and Turkey. It shows a crowd of transfixed Arab spectators surrounding the performers of this dangerous act in front of the dramatic, stage-like ruins of a temple. A similar scene was also the subject of one of Gérôme's most famous Orientalist works, *The Serpent Charmer* (cat. no. 15). In Ebers the reproduction is called *A Snake-Charmer in the Second Court of Medinet Haboo*, a specific title that clearly fulfills the book's "Descriptive" goal. The text accompanying the image, however, is strictly "Picturesque":

> This temple cannot fail to impress deeply any lover and connoisseur of architecture as a noble and grandiose production of the art. In its second court—if anywhere—with its colonnades, its pillars, and its statues, he must feel how admirably skillful the old masters were in producing novel and happy results by varying the forms of the supports in their buildings. The hollow cornice, bending over and closing in the space, which had no roof but the blue sky, has a fine effect and gives the spot a particular effect of calm retirement.

When contrasted with this account of the site's impact on the cultured tourist, Gentz's scene of idle pleasure in the shadow of ancient grandeur—where "calm retirement" is the appropriate response—functions as a criticism of local taste. It should be noted that the 1895 edition of Lane's book uses a similar, though simplified, line drawing of a snake

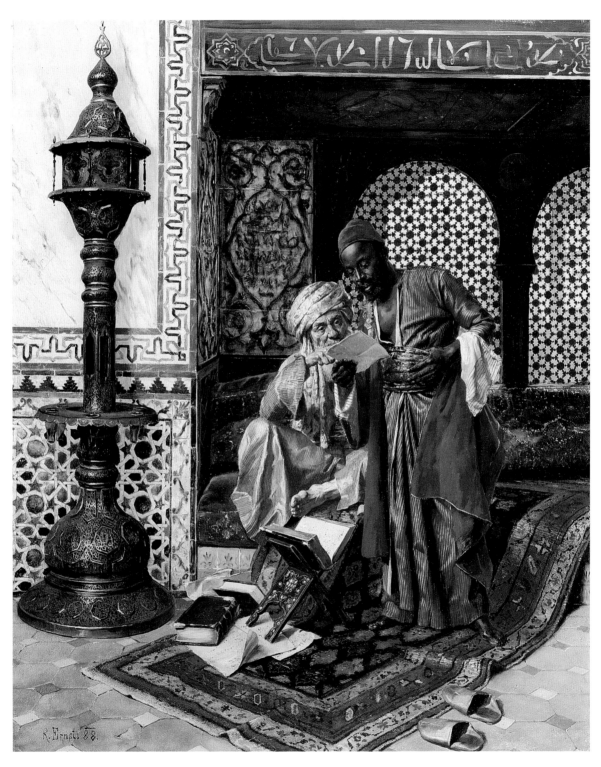

16. Rudolf Ernst (Austrian, 1854–1952), *The Letter*, 1888, oil on panel, 25¾ x 21 inches. Dahesh Museum of Art, 1995.53.

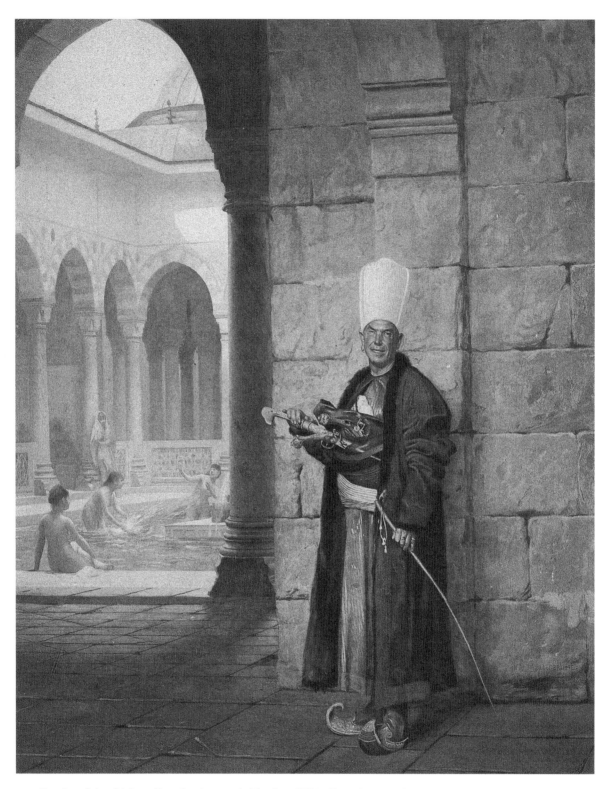

17. After Jean-Léon Gérôme (French, 1824–1904), *The Grand White Eunuch*, 1881, photogravure, 17⅛ x 11½ inches. Dahesh Museum of Art, 1997.57G.

charmer in the temple at Thebes (probably based on Gentz's image). But because it appears in a chapter describing the various pastimes and amusements of the local inhabitants, the negative subtext is not apparent.

One of the most complete sources of information on Islamic architecture and design was *Arab Art According to the Monuments of Cairo from the 7th Century to the End of the 18th Century*, published in 1877 by Achille Prisse d'Avennes, an engineer who worked for Egyptian ruler Muhammad Ali Pasha from 1826 to 1836, when he left to pursue archaeology. This collection of large-format lithographs depicts the interior and exterior details of mosques and other notable structures in Cairo. Most impressive are the color lithographs representing the multitude of intricate arabesque and geometric patterns found throughout Eastern art and architecture, a style Prisse deeply appreciated. The publication, with its exquisite details, was meant, and used, as a pattern book by decorative artists and architects. It also supplied Orientalist painters with the authentic architectural backgrounds and motifs they needed to enhance the realism of their works. The vividly rendered paintings of Rudolf Ernst, who specialized in scenes of daily life in the East, offer superb examples of how easily the penchant for accurate detail could transform a genre painting into little more than an excuse for decorative invention (cat. no. 16). His jewel-like paintings, which freely blend the architecture, artifacts and costumes of diverse cultures, are pattern book pastiches, in which activities like reading a letter or forging a lamp become enmeshed in the complex interplay of rich fabrics, geometric tiles and intricate metalwork.

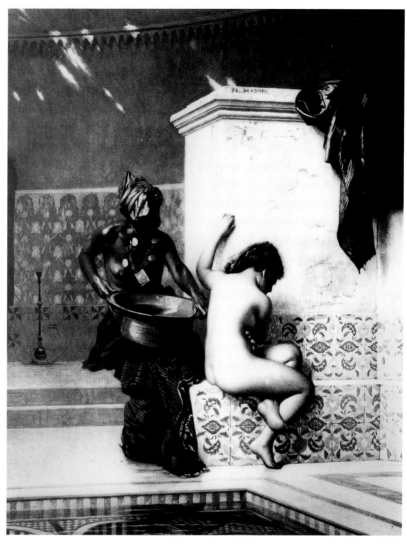

18. After Jean-Léon Gérôme (French, 1824–1904), *Moorish Bath*, 1881, photogravure, 17⅛ x 11½ inches. Dahesh Museum of Art, 1997.58H.

WOMEN AND MEN

Many of the stereotypes that are associated with 19th-century Orientalist painting revolve around the depiction of men and women. In Orientalism, as in genre painting in general, men were shown at worship, working at various tasks, selling wares or walking in the streets. Women were painted at the market, gathering water or playing with children. But for many in the West the defining features of the Orient were eroticism, violence, lassitude, mystery and danger. These were the attributes most commonly personified by men and women in Orientalist imagery. The Oriental body thus became a screen onto which the West could project its own desires, fears and sense of superiority.

Women were repeatedly pictured as dancers and harem odalisques—icons of sensuality and sexual

availability that conjured for a Western (male) audience an Orient of unlimited pleasure, in stark contrast to their own repressed society (cat. no. 17). In the work of Jean-Léon Gérôme these tropes were brought to their most refined form and disseminated to the widest audience, especially in America.

Gérôme made numerous trips to the Orient from the 1850s to about 1890, sketching, taking photographs and acquiring decorative objects to serve as props in his paintings. In 1863 he made an advantageous marriage to the daughter of international dealer and art publisher Adolphe Goupil. By the early 1880s, with the help of Goupil's publication of large-edition photogravures of Gérôme's paintings and sculpture, the artist received widespread international publicity. One of the most successful publications to use Goupil's photogravures was *Gérome: a collection of the work of J.L. Gerome in one hundred photogravures* (1881). Published in New York by one of Gérôme's American pupils, Earl Shinn (using the pseudonym Edward Strahan), the majority of these photogravures (a form of etching) depicted Gérôme's favored Orientalist subjects.

The white women in these images (fair-skinned Circassian or Georgian women were most prized in the seraglio) are presented for delectation: at the slave market, where they are examined by men and peddled like livestock; as dancers, gyrating with abandon in front of an appreciative male audience; or in the bathhouse, guarded by eunuchs and having their skin gently washed and massaged by black servants for the eventual pleasure of an unseen man. It was of no consequence that Gérôme, as a Western man, could never have seen the inside of a harem or bath (cat. no. 18). Artistic license and other sources were sufficient, as Shinn noted:

> . . . the skill of this particular painter is such that we are not at all troubled by the reflection that neither he nor any other man ever actually saw this Moorish lady at her luxurious ablutions. We may be sure that by a skillful combination of chosen models and studies of interiors the painter obtained data for something exceedingly like the scene he chose to illustrate.

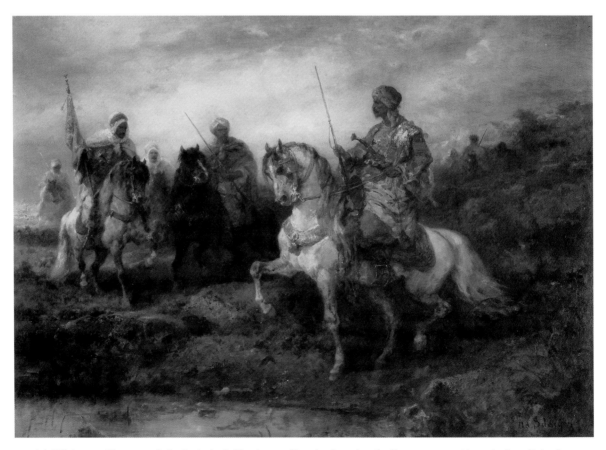

19. Adolf Schreyer (German, 1828–1899), *Arab Warriors on Horseback*, undated, oil on canvas, 34¼ x 47 inches. Dahesh Museum of Art, 1995.9.

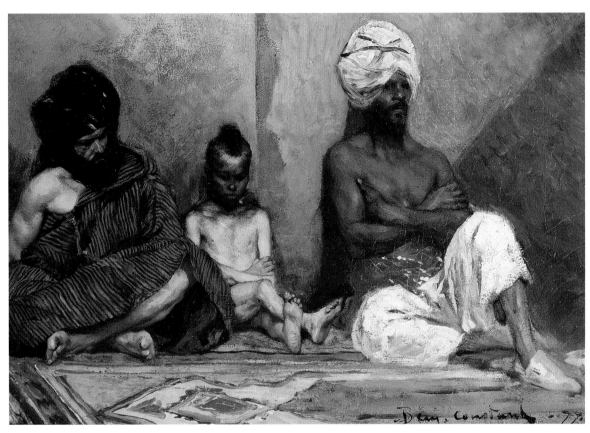

21. Jean Joseph Benjamin-Constant (French, 1845–1902), *Seated Arabs*, 1877, oil on canvas, 9 x 13 inches.
Dahesh Museum of Art, 1997.41.

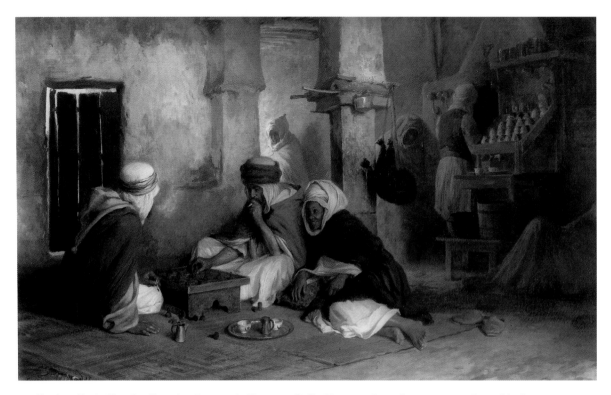

20. Eugène Alexis Girardet (French, 1853–1907), *Moroccan Coffee House*, c. 1874, oil on canvas, 29½ x 39½ inches. Dahesh Museum of Art, 1995.101.

Men were usually represented in Orientalist art as either martial or indolent, fierce soldiers or the idle habitués of coffee houses. Adolf Schreyer, a German artist who learned Arabic and immersed himself in Bedouin life, specialized in Arab warriors, earning the praise of Gautier, who described his work as "picturesque, dramatic and at the same time . . . realist." Schreyer's figures, like those in *Arab Warriors on Horseback* (cat. no. 19), are not actively engaged but vigilantly scanning the horizon, waiting for a conflict to arise. Georges Clairin, on the other hand, drops the viewer in the midst of raging combat in *Battle of Arabs*, with smoke, men and horses trampled underfoot and dead bodies. Clairin was not a witness to some internecine conflict, however, but rather a guest at a common equestrian entertainment in Morocco known as a *fantasia* (from the Arabic *fantaziya*, or "ostentation"). These were staged battles, often involving up to five hundred Arab horsemen galloping and shouting while brandishing and discharging their weapons. They were performed primarily for Westerners and are thus examples of the Orient itself participating in its own representation to the Occident.

Fabbio Fabbi's *Afternoon Smoke*, Joseph Austin Benwell's *Arab Encampment*, Benjamin-Constant's *Seated Arabs* (cat. no. 21) and Girardet's *Coffee House*

(cat. no. 20) are typical of the other approach, evoking a masculine sphere of continual lassitude that could produce both envy and smug self-satisfaction in an industrious Western viewer.

Perhaps the most fascinating depiction of the Arab warrior is found in the work of Gérôme (cat. no. 22). He combines the two predominant male stereotypes into what may be described as the lazy warrior. This is especially true in his representations of the supposedly ferocious Arnauts, descendants of the Albanian soldiers brought to Egypt by Muhammad Ali Pasha in the early 19th century, and the Bashi-Bouzouks, Ottoman irregular mercenaries. In most images they sleep, drink or smoke. Arms hang decoratively on the walls behind them while they luxuriate in moments of unprepared, and presumably drugged, relaxation. The obvious military impotence of these soldiers was no matter, as Cairo was firmly under the control of the ruling family and its Europeanized regular army in the Citadel overlooking the city. The colorful military subjects that Gérôme portrayed were merely the showy remnants of forces Muhammad Ali had largely exterminated years before in an effort to neutralize them as a threat. Their continued presence in the city was another instance of the East actively exploiting the Western fascination with its culture. As

Paul Lenoir, a student of Gérôme who accompanied him on two tours of Egypt (1868 and 1881) wrote, these soldiers "repose pictorially." Lenoir further addressed their self-conscious presence in this wonderfully visual description:

A military post was installed under the vault of the gate [the Bab al-Nasr or Gate of Victory in Cairo through which Napoléon first entered the city after his victory at the Battle of the Pyramids in 1798]; but it was for pure ornament and to give pleasure to painters. In regarding this group of soldiers, bedizened with brilliant costumes, the most serious doubts arose as to their strate-

disdainful attitudes, their least gestures, everything about them seems to have been most carefully studied. An amateur Soldier, he acquits himself of his rôle with care; and he has become the indispensable furniture of the door of a mosque or of the entrance to a palace. He is like the 'Swiss' [guards outside of the Vatican], the chasseur of our ancestors, but instead of the halbert he has about ten or a dozen weapons, sabres and pistols, artistically intercrossed in the compartments of a vast girdle of red leather, which gives him the aspect of one of the show-windows . . . on the boulevard Haussmann [in Paris]. . . .

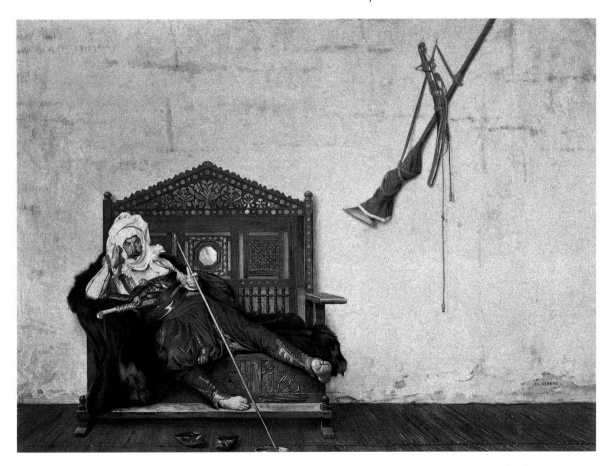

22. After Jean-Léon Gérôme (French, 1824–1904), *Arabian Warrior Resting*, 1881, photogravure, 11½ x 17⅞ inches. Dahesh Museum of Art, 1997.61E.

gic utility for the security of the city. . . . Whilst attending a new conquest of Egypt by whoever it may be, these soldiers of ornament, these opéra-comique sentinels have no other duty than to pose for any itinerant photographer that might honor them with his patronage. Their costumes artistically open at the breast, their arms "de luxe," brilliant and inoffensive, their proud and

It is noteworthy when men and women carry a more complex emotional charge in an Orientalist painting. Gustav Bauernfeind's 1888 masterpiece, *Jaffa, Recruiting of Turkish Soldiers in Palestine* (cat. no. 25), a deeply moving image of a modernized Ottoman military machine brutally conscripting the poorer members of its empire into the army, is a more blunt view of the Orient and its people than

23. After Owen Browne Carter (British, 1806–1859), *The Ghooreeyeh*, 1840, lithograph, 10¾ x 14⅝ inches. Dahesh Museum of Art, 1995.73.

24. John Varley, Jr. (British, fl. 1870–1895, died 1899), *The School Near the Babies-Sharouri, Cairo*, 1880, oil on canvas, 20 x 15 inches. Dahesh Museum of Art, 1995.60.

was usual in the 19th century. Here there are no dancing girls or odalisques, only women wailing and running into the surf after their men, holding infants over their heads. Far from ornamental, the Europeanized Ottoman soldiers standing on the sea wall dispassionately conduct the business of fulfilling conscription quotas. Neither fierce nor violent, the conscripts, probably poor peasants unable to pay the steep exemption tax, struggle desperately to get off the dinghies carrying them toward the large Ottoman steamship anchored outside the harbor.

UNDER A GOLDEN SKY

The 19th-century Orientalist landscape ranged from the strictly topographical or picturesque—"portraits" of famous buildings, views of ancient monuments and busy street scenes—to Romantic and timeless images of sunsets over the Nile and caravans traversing the desert sands. The subject was so appealing that in 1859 Gautier observed that ". . . the Sahara is dotted with as many landscapist's parasols as the Forest of Fontainebleau in days gone by."

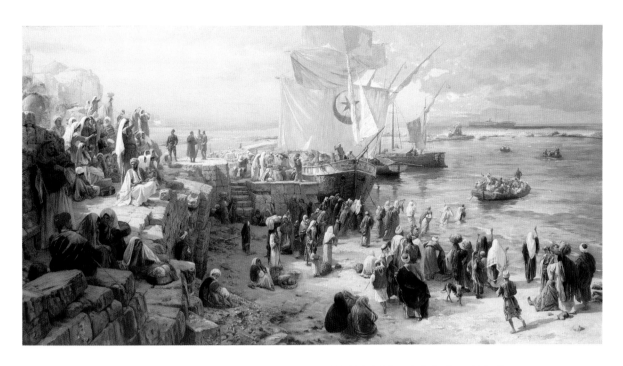

25. Gustav Bauernfeind (German, 1848–1904), *Jaffa, Recruiting of Turkish Soldiers in Palestine*, 1888, oil on canvas, 58¼ x 110⅛ inches. Dahesh Museum of Art, 1999.4.

The topographical approach is well illustrated by the lithographs made after drawings by architect Owen Browne Carter that comprised *Views in Cairo*, published in 1840 by millionaire antiquarian and explorer Robert Hay. Carter's studies of the *Mosque of El-Cuyooshee* and the *Gateway of Kasr Esh-Shema* offer precisely observed details of these religious and civic sites as they appeared in the early 19th century. His composition *The Ghooreeyeh* (cat. no. 23) is typical of urban topographic depictions, consisting of a varied crowd of figures in the foreground and a stage-like backdrop of architecture, with a glimpse of more buildings in the distance. Carter's attention to this famous market's architectural embellishments, the play of light across patterned facades, and colorful rugs and costumes reinforced Western perceptions of a picturesque Orient. So too did the many images of Cairo's narrow streets, flanked by dilapidated buildings and populated with colorful locals, a famous landmark or city vista dominating the background (cat. no. 24).

David Roberts, among the earliest professional artists to go to the Middle East, went with the express intention of publishing an album of topographical sketches upon his return. The British artist arrived in August of 1838 and toured Alexandria and Cairo, the major architectural wonders along the Nile and the Holy Land, returning to London in July of 1839. From

the sketches he made on this trip came the lithographs that illustrated his multi-volume opus *The Holy Land, Syria, Idumea, Egypt, Nubia*, published between 1842 and 1849. The illustrations in the book were accompanied by Roberts' own commentary, which was translated into several languages and published internationally. His text emphasized the distant biblical past rather than the recent past or present, and the book was immensely successful with a public eager to see the actual sites and landscape of the Old and New Testaments. The lithograph *Jerusalem from the Mount of Olives* (cat. no. 26), for example, clearly shows the Garden of Gethsemane, where Jesus was betrayed, at the foot of the Mount. The slopes of the Mount of Olives were a popular burial ground for Jews and pilgrims alike, since the Prophets proclaimed that the dead would be resurrected from this site.

The picturesque markets along the Nile and the tall-sailed Egyptian boats called *feluccas* moored off its banks were favorite motifs of landscapists seeking a more general impression of the Orient. The many temples built on the banks of the Nile were also an ideal subject for painters, who saw in them the very essence of ancient Egypt. Joseph Farquharson's sun-bleached view of the ruins of the Temple of Luxor conveys a sense of the oppressive heat beating down on the people gathered beneath the

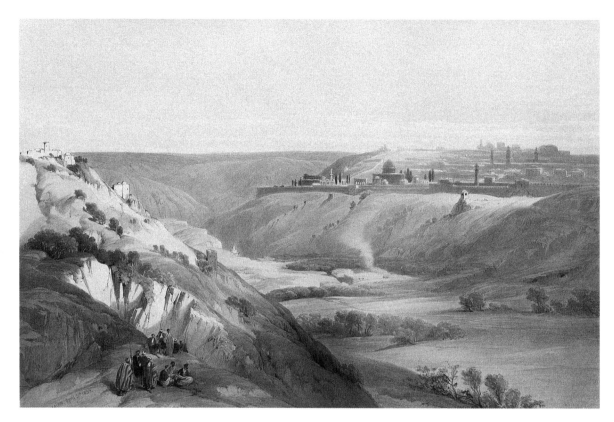

26. After David Roberts (British, 1796–1864), *Jerusalem from the Mount of Olives*, 1839, lithograph, 17 x 24 inches. Dahesh Museum of Art, 1995.72.

temple's remaining palm and papyrus bundle columns (cat. no. 27). The gigantic hieroglyphic-covered columns of the great Hypostyle Hall at the Temple of Karnak were a standard motif in both photography and painting (cat. no. 28). The emphatic linear perspective and small figures in Ernst Karl Eugen Koerner's painting (frontispiece) emphasize the hall's enormous scale. Like Farquharson, Koerner also captured the white heat of the desert by contrasting stark shafts of sunlight with the shadowed columns.

Capturing these particular qualities of light, as well as Egypt's glowing twilight skies and the pink, azure and gold sunsets over the Nile, presented a constant challenge to painters. One artist, Gustav Guillaumet, described the visual conditions he encountered:

> The decomposition and bleaching of tones in light, the coloration and transparency of shadows, the unpredictable play of reflections, the envelope of beings and things in this palpitating atmosphere that, in great bright landscapes such as these, bathes the dryness of lines as if in an imperceptible and vibrant fluid. . . .

This "palpitating atmosphere" became the subject of many works by Charles Théodore Frère, a master colorist and devoted Orientalist whose shimmering canvases won the admiration of Impressionists Claude Monet and Eugène Boudin. Frère traveled to Algeria in 1837 and then to Turkey, Syria, Palestine and Egypt in 1851. On his final trip in 1869, he accompanied Empress Eugènie's entourage to Egypt for the opening of the Suez Canal. He subsequently established a permanent studio in Cairo and was eventually awarded the title of *bey* (lord) by the Egyptian government. Vibrant, exaggerated colors heighten the dramatic effect of *Along the Nile at Gyzeh*, suggesting the timeless rhythm of life unfolding along the Nile in the shadow of the Pyramids (cat. no. 29).

The delicate gradations of luminous color and sparkling reflections in Italian painter Hermann-David-Salomon Corrodi's romantic vision of sunset over the Nile also evoke a world where past and present merge (cat. no. 30). His subject, the picturesque little temple known as Pharaoh's Bed, was a stock Orientalist motif. In 1877, British travel writer Amelia Edwards asserted that the structure "has been so often painted, so often photographed that

27. Joseph Farquharson (Scottish, 1846–1935), *The Ruins of the Temple at Luxor*, c. 1890, oil on canvas, 24 x 26½ inches. Dahesh Museum of Art, 1995.7.

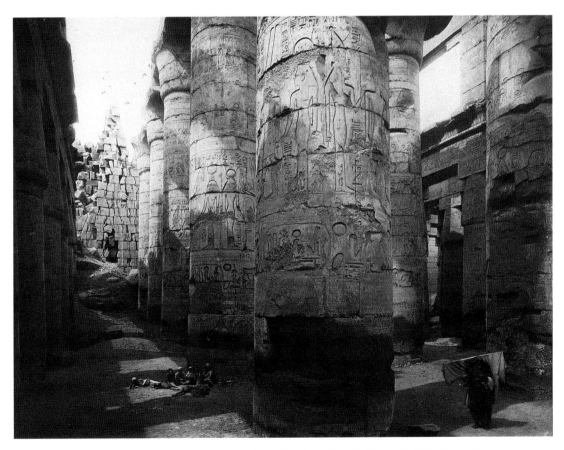

28. R.M. Junghaendel (German, dates unknown), *Great Temple at Karnak, Hypostyle Hall*, 1893, heliogravure (photogravure), 17 x 21¼ inches. Dahesh Museum of Art, DM1803G.

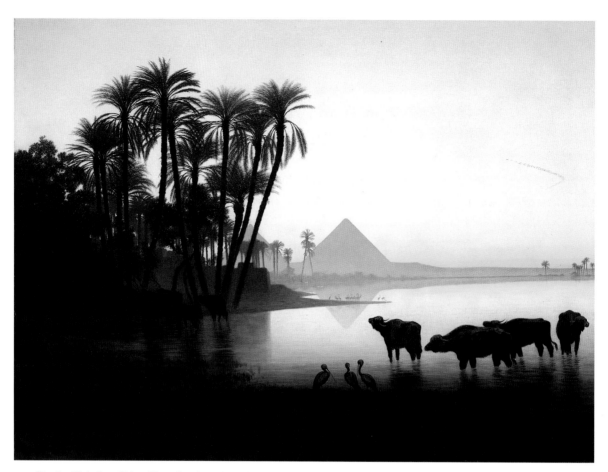

29. Charles Théodore Frère (French, 1814–1888), *Along the Nile at Gyzeh*, c.1850s, oil on canvas, 38 x 51 inches. Dahesh Museum of Art, 1995.102.

every stone of it . . . and the tufted palms that cluster around about it, have been since childhood as familiar to our mind's eye as the Sphinx or the Pyramids." Some, however, preferred an even more familiar landscape. In 1857 Jules-Antoine Castagnary, critic and champion of the Realist painter Gustave Courbet, addressed Orientalists with this provincial reprimand: "Now your desert, your palm trees, your camels, they may dazzle my mind, but they will never give me the sweet and peaceful emotion I have at the sight of cows in a meadow bordered by poplars. . . "

European artists perceived and interpreted the realities of Eastern culture through Western eyes, creating a visual tradition that freely commingled fact and fantasy. The best Orientalists portrayed the fascinating people and landscapes of regions that had long and varied histories of their own, but were utterly new to most of the West. Some of the imagery is indeed laced with the ideological biases and colonial worldviews of the West, presenting an Orient reduced to a series of stereotypes—dangerous, exotic, backward. But many of the works also reflect a

respect for the culture, the deeply felt practice of Islam, the architecture and the beauty of its people. In the end, one cannot help but marvel at the sheer visual pleasure of Orientalist images: the blazing sunsets, the sumptuous fabrics and elaborate patterns, the play of light and shadow across pale bodies, the dizzying details. Writing about France's greatest Orientalist painter, Jean-Léon Gérôme, his American pupil Earl Shinn perfectly articulated the hegemony in Orientalism of paint over polemics:

No modern artist is more absolutely free from this most inartistic sin of preaching, or philosophizing, or moralizing, or lamenting, or exhorting, or, in fact, appealing to the mind in any other manner than through the eye. He is not at all concerned with the cruelty of his Pashas, the ferocity of his Arnauts, the degradation of his women of the Harem—if he were, he would not paint them so well.

Lisa Small
Research Associate

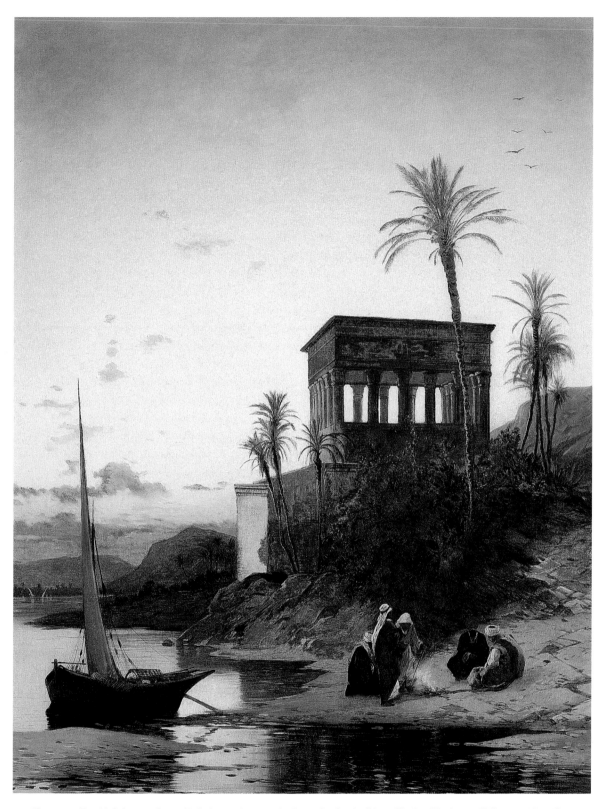

30. Hermann-David-Salomon Corrodi (Italian, 1844–1905), *Campfire by the River: Kiosk of Trajan at Philae*, c. 1880, oil on canvas, 40 x 25¾ inches. Dahesh Museum of Art, 1995.20.

Suggested Reading

Ackerman, Gerald M. *American Orientalists*. Paris: ACR Edition, 1994.

_____. *Jean-Léon Gérôme*. Paris: ACR Edition, 2000.

Beaucour, Fernand; Yves Laissus and Chantal Orgogozo. *The Discovery of Egypt*. Paris: Flammarion, 1990.

Benjamin, Roger, ed. *Orientalism: Delacroix to Klee*. Sydney: The Art Gallery of New South Wales, 1997.

Dahesh Museum. *Image and Text: Orientalist Works on Paper from the Permanent Collection*. New York: Dahesh Museum, June 30–September 5, 1998.

_____. *Picturing the Middle East: A Hundred Years of European Orientalism*. New York: Dahesh Museum, October 17, 1995–January 27, 1996.

Edwards, Holly, ed. *Noble Dreams, Wicked Pleasures: Orientalism in America, 1870–1930*. Williamstown: Sterling and Francine Clark Art Institute, 2000.

Jullian, Philippe. *The Orientalists: European Painters of Eastern Scenes*. Oxford: Phaidon, 1977.

Nochlin, Linda. "The Imaginary Orient." In *The Politics of Vision: Essays on Nineteenth-Century Art and Society*. New York: Harper & Row, 1989.

Rosenthal, Donald A. *Orientalism: The Near East in French Painting, 1800–1880*. Rochester: Memorial Art Gallery, 1982.

Said, Edward S. *Orientalism*. New York: Vintage Books, 1979.

Stevens, MaryAnne, ed. *The Orientalists: Delacroix to Matisse: European Painters in North Africa and the Near East*. London: Royal Academy of Arts, 1984.

Thornton, Lynne. *The Orientalists: Painter-Travellers*. Paris: ACR Edition, 1994.

_____. *Women as Portrayed in Orientalist Painting*. Paris: ACR Edition, 1994.

Thompson, James. *The East: Imagined, Experienced, Remembered*. Dublin: National Gallery of Ireland, 1988.